"FRIEZE OF DANCERS" by Edgar Degas *(cont.)*

5. Color in entire drawing. Give your work a title or name. Refer to "The Frieze of Dancers" for an example.

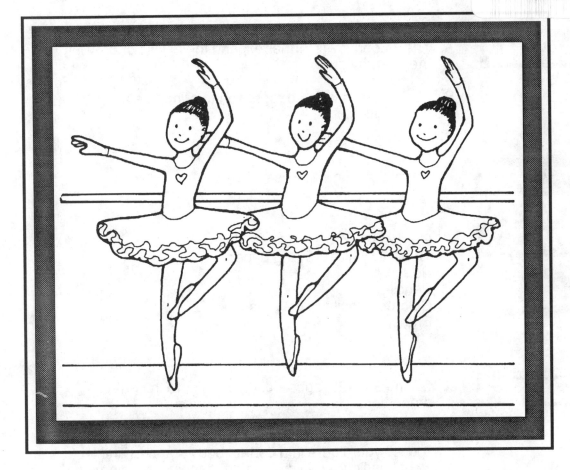

Evaluation:

A. Did the student understand the concept introduced?

B. Did the student use repetition in his/her composition?

C. Did the student complete the project?

MASTERPIECE: "FRIEZE OF DANCERS" by Edgar Degas

CONCEPT:	FIGURE
GRADE:	FIFTH
LESSON:	REPEATED FIGURES

Objectives:

A. The students will further expand their skills of drawing the human figure.

B. The students will use repetition to complete a composition.

Vocabulary:

Repetition, Figure, Pose, Title

Materials:

9"x 12" tagboard
12"x 18" white drawing paper
Scissors
Pencil
Colored pencils or crayons
Eraser

Process:

1. On the 9"x 12" tagboard, draw a figure in correct proportions.

2. If needed, erase and redraw the arms and legs to "pose" your figure in a certain body stance. Think of what this figure could be doing: dancing, running, working, playing, etc.

3. Cut out this figure. This will be your pattern.

4. On the horizontal white paper, trace this figure pattern several times across the page. Overlap some figures so they appear to be behind or in front of one another.

 * Remember that objects in front of others are placed lower on the page...objects in the back are placed further up on the paper.

"PROFILE OF A YOUNG MAN" by Masaccio (cont.)

5. Start your profile sketch in pencil. You may use the models throughout the drawing or just use them for steps 2 through 4 to demonstrate the feature placements.

6. Add features onto your profile pencil sketch. Try to depict a well-defined (clean-cut) contour. Add details for a costume, jewelry and hair style.

7. Create a deep-space scene in the negative space (the background). This could be a castle, countryside, courtyard, etc... Remember rules of showing space in a drawing from previous lessons.

8. Color in areas; then outline with a marker.

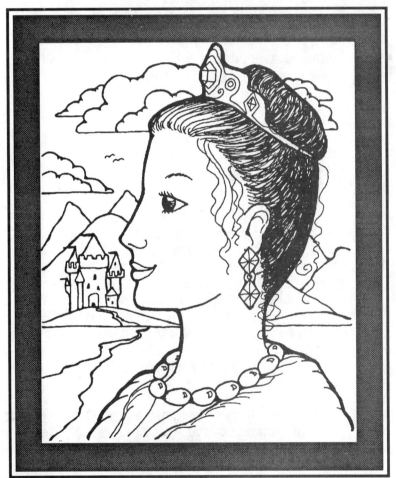

Evaluation:

A. Did the student understand the concept introduced?

B. Did the student use correct proportions in their profile drawing?

C. Did the student create an imaginative background?

CONCEPT:	PORTRAIT--PROFILE
GRADE:	FIFTH
LESSON:	RENAISSANCE PROFILE

Objectives:

A. The students will be exposed to the Renaissance Period in art.

B. The students will create a portrait using Renaissance influence.

Vocabulary:

Renaissance, Negative Space, Profile, Positive Space

Materials:

12" x 18" drawing paper
Markers
Crayons

Process:

1. Explain that a profile is a side view of a person's face. Many profiles were painted in this style during the Renaissance era in Italy. This same profile style is also found on Roman coins. Renaissance profiles showed well-defined contours and also used the space behind the face (the negative space) as part of the overall picture.

2. Have one or a group of students take turns modeling and sit in a profile position.

3. Notice placement of features as they relate to each other: the corner of the eye is in line with the top of the ear and the bottom of the ear lines up with the bottom of the nose.

4. Notice that the eyes look different from the side than they do from the front. Also notice the rounded proportion of the back of the head.

"VINCENT'S BEDROOM" by Vincent van Gogh *(cont.)*

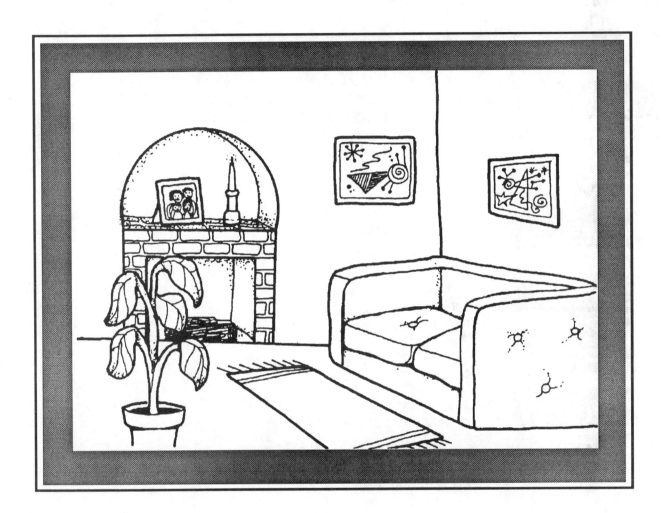

Evaluation:

A. Did the student understand the concept introduced?

B. Did the student use color varieties on the objects?

C. Did the student show creativity?

CONCEPT: INTERIOR

GRADE: FIFTH

LESSON: ROOM DRAWING

Objectives:

A. The students will further expand their knowledge of working with perspective.

B. The students will experiment with drawing interiors.

Vocabulary:

Interior, Perspective, Color

Materials:

12" x 18" white paper
Oil pastels (chalk or crayons)
Ruler
Pencil

Process:

1. Think of an interior of a room to draw. It could be any room of your choice.

2. Draw the interior of your room. Keep the objects simple and do not clutter drawing with too many objects.

3. Notice how Vincent van Gogh used perspective: the end of the bed is enlarged because it is closer, the lines on the floor, overlapping shapes, etc. Try to use perspective in your drawing.

4. Color in your picture. Note van Gogh's use of color in this painting. Let this style of mixed color and short brushstrokes influence your work.
 * One object does not have to be all one color!

"BLACK IRIS" by Georgia O'Keeffe *(cont.)*

* Avoid outlining shapes with dark, thick lines of paint. Try using color to create edges instead of outlining the shapes...A yellow-orange portion of a petal overlapping a light yellow portion of another petal will create that edge without the use of an outline.

4. Let dry.

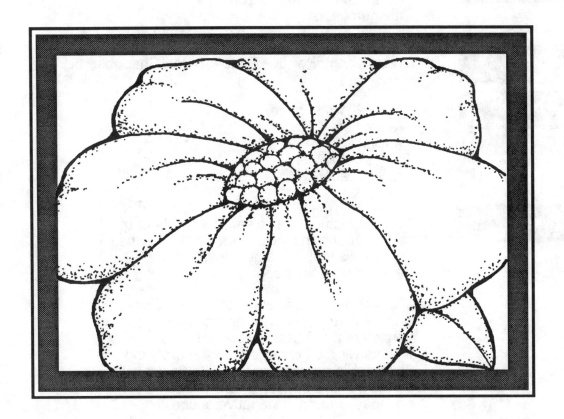

Evaluation:

A. Did the student understand the concept introduced?

B. Did the student show enlargement on his/her finished work?

C. Did the student handle the media to the best of his/her abilities?

MASTERPIECE: "BLACK IRIS" by Georgia O'Keeffe

CONCEPT: NATURE

GRADE: FIFTH

LESSON: ENLARGED FLOWERS

Objectives:

A. The students will expand their realistic drawing skills to include drawing enlargements.

Vocabulary:

Enlargement, Positive Space, Color, Shape

Materials:

12" x 12" white paper
Watercolors
Pencils
Pictures of flowers
Tracing paper

Process:

1. Select a picture of a flower. Lay a sheet of tracing paper on it. Draw the lines, shapes and details that make up this object by tracing it onto the paper.

2. The tracing process is for practice. Now, on the white paper draw an enlarged version of this flower. Discuss how the flowers will look enlarged. Try to draw the flower as large as possible. The flower will be the positive space. There will be little, if any, background or negative space.

 * To help students draw large, suggest that a portion of the flower should touch each of the four edges of the drawing paper.

3. Paint the enlarged flower drawings with watercolors. Use the watercolors in diluted form, first using pale colors then darker colors. Leave areas of white showing by not painting some areas of the paper.

"IRIS" by Vincent van Gogh *(cont.)*

4. Paint the background areas of the painting first and then work towards the other areas. Do not apply paint too thick or it will crack when dry and fall off the paper!

5. Paint in all areas and let painting dry overnight.
 * You may use some paints that are thicker than others.

Evaluation:

A. Did the student understand the concept introduced?

B. Did the student use good composition to the best of his/her ability?

C. Did the student complete the project?

MASTERPIECE: "IRIS" *by Vincent van Gogh*

CONCEPT:	ARTISTIC STYLE
GRADE:	FIFTH
LESSON:	IMPASTO PAINTING

Objectives:

A. The students will explore a style of an artist.

B. The students will experience a new painting technique.

Vocabulary:

Impasto, Vincent van Gogh, Composition

Materials:

12" x 18" poster board
Tempera paint
White soap flakes
Water containers
Paint trays
Brushes

Process:

1. Draw a picture for your painting. It can be anything of your choice...be creative! Use good composition in arranging objects in your picture. Avoid using small details...they will not show up in the finished painting.

2. Impasto is a style of painting that Vincent van Gogh used. The paint is applied in a very thick, paste-like manner. The finished paintings will have a rough texture.

3. Mix about 1/2 cup of soap flakes to one cup of tempera paint.

 * All paint varies for several reasons, so just mix until the paint is the right thickness, some paints take more and some will take less soap. Mix until the paint is like a thick pancake batter.

"GIRL WITH A DOVE" by Pablo Picasso *(cont.)*

4. Paint the still life drawing using the analogous colors. Mix the two main colors together in different quantities. Also, mix white and black to these different colors to create tints and shades.

5. Paint patterns onto dry areas if desired.

 * Paint background as well as the still life objects.

6. Let dry.

Evaluation:

A. Did the student understand the concept introduced?

B. Did the student use an analogous color scheme?

C. Did the student complete the activity?

CONCEPT: ANALOGOUS COLOR

GRADE: FIFTH

LESSON: ANALOGOUS STILL LIFE

Objectives:

A. The students will further enrich their knowledge of color theory.

B. The students will complete a mixed media project.

Vocabulary:

Analogous, Contrast, Center of Interest, Hue

Materials:

12" x 18" white paper
Tempera paint
Brushes
Paint trays
Still life objects
Pencil

Process:

1. Analogous colors are colors that are adjacent (side-by-side) on the color wheel. For example, one scheme of colors could be Yellow, Green, Yellow-Green and tints and shades made by mixing white or black to any of these three colors in different quantities (i.e. light green, lighter green, very light green, etc.).

2. Set up a still life and draw it on the white paper. Keep drawing large...fill up the entire page. Create a center of interest.

3. Select a set of analogous colors to work with. Put these main colors plus black and white on the paint tray.

6. Outline objects with a black marker or a thin brush and black tempera.

7. Cut out horses. * You may add a striped pole to your horse.

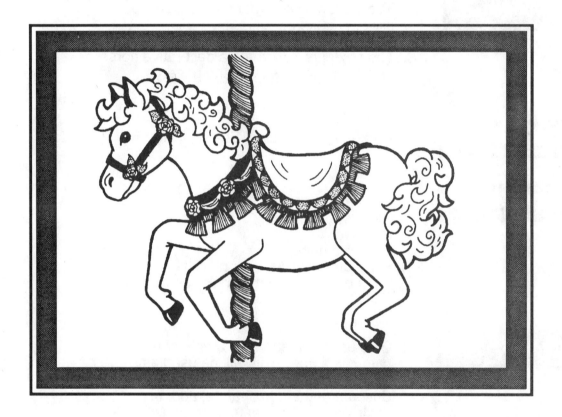

Evaluation:

A. Did the student understand the concept introduced?

B. Did the student handle the media correctly?

C. Did the student use his/her creativity to complete a decorative horse?

MASTERPIECE: "CIRCUS" by Georges Seurat

CONCEPT: ANIMALS

GRADE: FIFTH

LESSON: CAROUSEL HORSES

Objectives:

A. The students will expand their drawing skills.

B. The students will create a decorative horse using line, color, shape and patterns.

Vocabulary:

Carousel, Color, Line, Shape, Pattern

Materials:

18" x 24" tagboard
Pencils
Brushes
Tempera paint
Thick black markers (or black tempera)
Picture of a carousel horse (see next page)

Process:

1. Give each student an example of a carousel horse. This will be used as a source picture for their drawing. Encourage them to change, add, or combine parts to create their own style of horse.

2. Draw the basic horse shape on the 18" x 24" tagboard.

3. Add details to this horse: saddle, reins, fringe, straps, etc.

4. Paint areas with tempera paint. * You may leave your horse the white color of the paper.

5. Let paint dry.

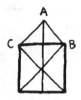

7. Draw a vertical line straight up from the center of the "X." Draw it as tall as you want the peak of the roof to be.

8. Connect the top of this line (A) to the two top corners of the square (B & C).

9. Draw a line that connects from point (A) to the vanishing point. This will form the top of the roof.

10. Line your ruler up with points "A & B." Slide the ruler back at this same angle to point "D." Draw a diagonal line from the top of the roof to point "D."

11. Erase all lines that start at the back edge of the house and extend to the vanishing point.

12. Try more buildings on either side.

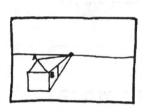

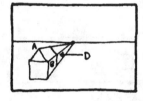

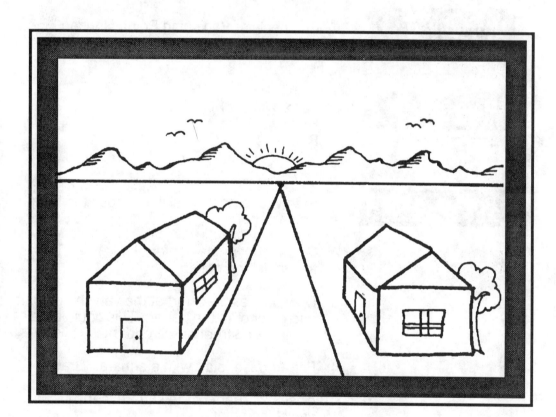

Evaluation:

A. Did the student understand the concept introduced?

B. Did the student use a vanishing point to show depth?

C. Did the student complete the drawing?

MASTERPIECE: "ST. ROMAINE QUARTER" *by Maurice Utrillo*

CONCEPT: PERSPECTIVE

GRADE: FIFTH

LESSON: 1-POINT PERSPECTIVE SCENE

Objectives:

A. The students will be exposed to a new drawing technique.

B. The students will use creativity to complete a perspective landscape.

Vocabulary:

Perspective, Vanishing Point, Horizon Line, Vertical Line

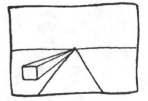

Materials:

12" x 18" Drawing Paper
Ruler
Pencil

Process:

1. Start with a horizontal line across the length of the paper.

2. Place a dot in the center of this line. This is the vanishing point.

3. Draw 2 lines that start at the vanishing point and extend off the paper. This could be a road, river, street or railroad tracks.

4. For a house, start with a square. Draw a line to the vanishing point from the 3 closest corners of the square to the vanishing point.

5. Draw one vertical line (D) on this area to create the back corner of the house.

6. Draw an "X" in the square by connecting diagonal corners with a light pencil line.

"INTERIOR WITH EGYPTIAN CURTAINS"
by Henri Matisse *(cont.)*

5. Use the chalk to draw designs onto the painting when dry. Use patterns, repeating shapes and inventive shapes to create your decorative design pattern. Refer to Matisse's use of patterns and designs.

6. Spray with a fixative to prevent the chalk from smearing.

Evaluation:

A. Did the students understand the concept introduced?

B. Did the student show creativity in his/her designs?

C. Did the student handle the materials correctly?

MASTERPIECE: "INTERIOR WITH EGYPTIAN CURTAINS"

by Henri Matisse

CONCEPT: COMPLEMENTARY COLORS

GRADE: FOURTH

LESSON: DECORATIVE STILL LIFE

Objectives:

A. Students will expand their painting and drawing skills.

B. Students will use their creativity to create designs using patterns, rhythm, and repetition.

Vocabulary:

Interior, Pattern, Shape Rhythm, Repetition

Materials:

12" x 18" tagboard or poster board
Tempera paint
Assorted colored chalk
Spray fixative (or hair spray)
Still life objects

Process:

1. Set up a few still life objects in front of small groups of students.

2. Each student should draw 3-4 still life objects on tagboard. Draw large. Start drawing about 2-3 inches from the bottom of the paper. The objects can run off the top or the sides of the paper but not the bottom.

3. Add a table or some other surface to make the objects look as if they are sitting on a surface. This can be created by placing a horizontal line behind the objects already drawn.

4. Paint the drawing with tempera paint. Paint the areas solid colors. Let dry.

"THE BROOKLYN BRIDGE" by Joseph Stella *(cont.)*

* Lay the ruler down and trace on both sides of the ruler to create an evenly drawn thick line.

* At least one end of each of these lines should run off the edge of the paper.

4. Use the colored chalk to color in the empty areas created between these thick lines. Do not color inside the stripes.

5. Paint the thick stripes with black tempera paint. Let dry. Spray fixative to seal the chalk.

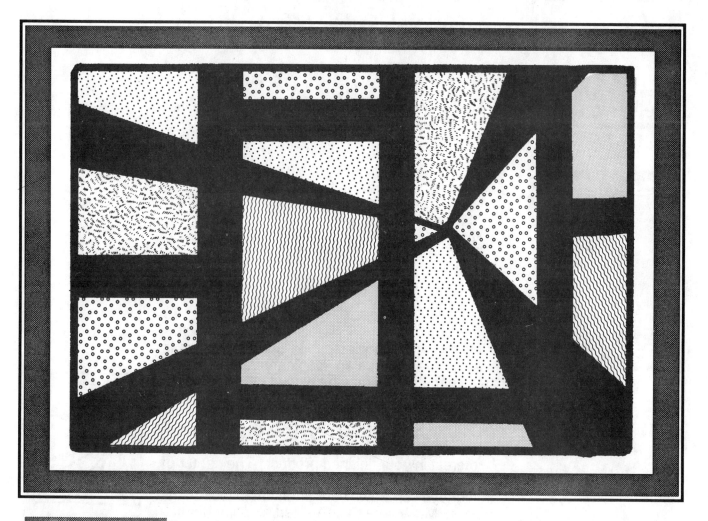

Evaluation:

A. Did the student understand the concept introduced?

B. Did the student handle media to the best of his/her abilities?

C. Did the student create a center of interest in his/her work?

MASTERPIECE: "THE BROOKLYN BRIDGE" *by Joseph Stella*

CONCEPT: LINE

GRADE: FOURTH

LESSON: BLACK LINE DESIGN

Objectives:

A. The students will experience working with mixed media.

B. The students will further expand their knowledge of composition and design.

Vocabulary:

Line, Horizontal, Vertical, Composition, Center of Interest

Materials:

12"x 12" or larger white construction paper
Chalk—assorted colors
Black tempera paint
Rulers
Pencils
Brushes
Spray fixative(or hair spray)

Process:

1. On the white drawing paper, place a dot that is somewhere inside an imaginary frame around the paper. This may be placed in the center or better yet, off center.

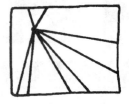

2. Use the ruler to draw thick lines that come out from this point. This point will be the center of interest in your finished product. The center of interest is that part of the work that "catches your eye" or draws your attention to look at that area. Make sure that the starting point of each line starts at the dot. The line (or stripe) should get wider as it goes out to the edge of the paper. Draw 3-6 lines that originate from that dot.

3. Now, draw several thick horizontal and vertical lines on this drawing.

4. Very lightly with your pencil, draw a simple contour line drawing of the head and chest of the model.

5. Use watercolors to paint your portrait. Use lots of water with the colors so that the paint is light and transparent in most of the areas. Avoid using a lot of thick paste-like paints when painting with watercolors. Your colors should be thin and able to blend together. Let dry completely.

6. Turn dry painting over on a few layers of newspapers. Rub the back of the painting with a crumbled paper towel soaked with baby oil. As paper soaks up the oil and looks as if it's wet, move on to another area of the dry paper until all of it is oiled.
 * A little oil will go a long way!

7. The baby oil will make your painting look transparent or see-through. Let dry overnight or rub with dry towels to get the excess oil out. Hang in window to display!

Evaluation:

A. Did the student understand the concept introduced?

B. Did the student use creativity in his/her painting?

C. Did the student complete the project?

CONCEPT: ARTISTIC STYLE

GRADE: FOURTH

LESSON: TRANSPARENT RENOIR PORTRAIT

Objectives:

A. The students will experiment with a new method of painting.

B. The students will create a transparent painting which resembles qualities of Renoir's style.

Vocabulary:

Porcelain, Transparent, Luminous, Impressionist, Automation

Materials:

Baby oil (or popcorn, cooking, or salad oil)
Watercolors
12" x 18" White drawing paper
Paper towels
Old fancy hats
Newspapers

Process:

1. Before Pierre-Auguste Renoir became an Impressionist painter, he was a porcelain painter in a French town called Limoges which is famous for its china, named after the town. Renoir lost his job due to automation. He took up painting on canvas and used that same luminous quality of colors used on the porcelain paintings.

 Renoir like to paint parks, beaches, sidewalk cafes, and females wearing hats and bows. Many of his paintings have a red hat, a red rose, or a red bow in them.

2. You will be creating a portrait which will resemble this luminous and transparent color quality used by Renoir.

3. Choose a few models to pose with the fancy hats on. * You may also wish to use fancy tops or dresses.

"JANE AVRIL" by Henri de Toulouse-Lautrec *(cont.)*

5. After the large areas of color are dry, draw the lettering on for the heading. * The letters will be easier to paint onto a painted surface rather than to draw on first and try to paint around.

6. Sign your autograph to your work.

Evaluation:

A. Did the student understand the concept introduced?

B. Did the student show creativity?

C. Did the student complete the project?

MASTERPIECE: "JANE AVRIL" by Henri de Toulouse-Lautrec

CONCEPT: COMPOSITION

GRADE: FOURTH

LESSON: POSTER

Objectives:

A. The students will create a poster with the influence of Toulouse-Lautrec present in their finished product.

B. The students will be exposed to a new style of painting.

Vocabulary:

Poster, Illustration, Thumbnail

Materials:

18" x 24" poster board
Tempera paint
Brushes
Pencil
Examples of Toulouse-Lautrec's work

Process:

1. Look at the examples of Toulouse-Lautrec's work. Notice the large flat areas of color, the words and the outlines. Note how the artist signs his work.

2. Think of a subject to paint in your poster. You may wish to try a few thumbnail sketches (small practice drawings) of your ideas. Think of a heading, large areas of color and a signature. You may wish to practice your autograph.

3. Draw the outline shapes onto your poster.

4. Paint large areas with thick brushes. Next, use the smaller brushes for details and for letters.

"RHINOCEROS" by Albrecht Dürer *(cont.)*

Evaluation:

 A. Did the student understand the concept introduced?

 B. Did the student use line creativity to show texture and pattern?

 C. Did the student complete the project?

CONCEPT: LINE/TEXTURE ANIMAL

GRADE: FOURTH

LESSON: CREATIVE TEXTURED ANIMAL

Objectives:

A. The students will experience using creative textures and patterns to create an inventive drawing.

B. The students will expand their skills in using variations of lines in their work.

Vocabulary:

Texture, Pattern, Line, Contrast

Materials:

9" x 12" white drawing paper
Pencil
Thin magic markers

Process:

1. With a pencil, lightly draw a close-up view of the animal in nature. Enlarge the drawing so that it takes up the entire paper. Remaining space will be drawn as the animal's environment.
 * For now, only draw outline shapes of the objects.

2. Outline completed drawing with the marker. Create inventive textures by using patterns within the shape of the objects.

 * Contrast will be created by placing lines closer together for dark areas and farther apart for lighter areas. Outline and pattern the objects in the environment also.

 * To create a focal point, try to create a simpler background and a more detailed subject.

"DEMPSEY & FIRPO" by George Bellows *(cont.)*

3. Practice several different poses. Start out with about 1 minute per drawing and work down to 30 seconds or so.

4. Now, use the white drawing paper. First, you will look at examples of the artists listed above. How are the sports figures drawn or posed to show motion? Pick your favorite pose or get an idea in mind for your sports figure drawing.

5. Draw a chalk gesture of the sports figure of your choice on the white paper.

6. Work lightly to avoid getting a lot of chalk dust on your paper.

7. Color with pastels. Slow down and take your time to color the figure in. Add any team colors or uniform to the figure. The entire figure should be colored in so it looks real.

8. Cut out the figure. Glue it onto a sheet of colored construction paper.

9. Cut this out so that about 1-inch of the colored paper shows around the figure. Glue this onto another sheet of colored paper. Continue this process until you have 2 or 3 border colors around your figure. The last colored paper should be left uncut so that it forms a rectangular frame.

Evaluation:

A. Did the student understand the concept introduced?
B. Did the student show motion in his/her figure?
C. Did the student complete the project?

CONCEPT: FIGURE ART

GRADE: FOURTH

LESSON: GESTURE SPORTS FIGURE

Objectives:

A. Students will experience gesture drawing.

B. Students will expand a gesture drawing into a figure in motion.

Vocabulary:

Gesture, Motion

Materials:

Practice drawing paper
12" x 18" white drawing paper
Yellow chalkboard chalk
Pastels or oil crayons
Scissors
Glue
Assorted construction paper, 12" x 18"
Reproductions of works by artists:
George Bellows, Leroy Nieman, and Edgar
Degas (ballerinas)

Process:

1. Practice gesture drawings. You are trying to catch the gesture of the model in a very short period of time. Think of the inside of the model as being made of a wire form. Try drawing the inside form of the body in this wire-like form. A spiral or "slinky" (like the toy) line is the easiest to teach your students.

2. Start practices by having a model pose. Start at the head and work your way down. Use thicker spirals for the body and thinner spirals for the arms and lower legs. Try not to pick the pencil up off the paper! Remember you are only drawing the inside of the figure...DO NOT outline any parts of the figure!

"CHRISTINA'S WORLD" by Andrew Wyeth *(cont.)*

4. Mix a little more of the color to the white color and continue to paint each section down from the top of the paper. Each section should be a slightly darker color as it is lower on the paper. Let dry.
 * Value perspective shows colors up close as bright and vivid...colors farther away are lighter and not as bright.

5. From the assorted construction paper, draw an object that would fit into the landscape.

6. Draw this same object in a medium size and in a small size. Cut out these objects and outline any details with a marker.
 * Diminishing size shows the same sized object in different sizes according to how close or far they are from the viewer.

7. Glue these objects onto the dry painting. The largest object is placed closest to the bottom of the paper, the medium size placed higher up from the bottom of the paper, and the smallest object placed the highest up on the paper.

Evaluation:

A. Did the student understand the concept introduced?
B. Did the student handle the media to the best of his/her abilities?
C. Did the student achieve perspective through the use of color and size?

CONCEPT:	PERSPECTIVE (VALUE)
GRADE:	FOURTH
LESSON:	VALUE LANDSCAPE

Objectives:

A. The students will further expand their techniques for using perspective.

B. The students will use diminishing size and color values to create a landscape.

Vocabulary:

Value, Landscape, Perspective, Diminishing Size

Materials:

Tempera paint--each student will need one color of their choice plus white
Assorted construction paper
Brushes
12" x 18" white paper
Scissors
Glue
Markers
Pencil
Paint tray
Newspaper

Process:

1. Think of a landscape. Draw several horizontal lines across the paper. These may be curvy hills, zig-zag mountains or any other inventive lines.

2. Place paper on newspaper.

3. Choose one color plus white for your paint tray. Mix one small brush load of that color to the white paint. Paint this very light color on the top section.

Evaluation:

A. Did the student understand the concept introduced?

B. Did the student use correct proportions on the portraits?

C. Did the student show creativity in his/her work?

CONCEPT: PORTRAIT

GRADE: FOURTH

LESSON: DECORATIVE BACKGROUND PORTRAIT

Objectives:

A. The students will expand their portrait drawing skills.

B. The students will create a mixed media portrait influenced by an artist's style.

Vocabulary:

Background, Decorative, Portrait

Materials:

Scraps of Wallpaper
12" x 18" Drawing Paper
12" x 18" Construction Paper (use assorted colors in surplus...they won't show when finished)
Glue
Scissors

Process:

1. On the 12" x 18" drawing paper, draw a portrait of a family member or a friend. (The Roulins were friends of Van Gogh's and he painted several members of their family.) Draw large, from the chest up. *Remember correct placement of the features.

2. Color or paint the portrait. Let dry.

3. Cut out the portrait.

4. Choose a scrap of decorative wallpaper for the background. Glue this onto the 12 x 18 construction paper so it covers at least the top two-thirds of the paper.
* You may wish to show other decorative background portraits by Vincent van Gogh. Before you start, students may like to find wallpaper to match his/her background. Add markers or paint to some wallpaper designs to make them more decorative.

"MAN WITH HELMET" by Rembrandt van Rijn *(cont.)*

4. Using a paint tray, choose one color with black and white. Paint your portrait using the color you selected plus the different combinations you can make by adding different amounts of black or white. Paint the background also.

Evaluation:

A. Did the student understand the concept introduced?

B. Did the student use correct methods of mixing colors?

C. Did the student complete the project?

MASTERPIECE: "MAN WITH HELMET" *by Rembrandt van Rijn*

CONCEPT:	PORTRAIT-VALUE
GRADE:	THIRD
LESSON:	MONOCHROMATIC PORTRAIT

Objectives:

A. The students will expand their knowledge of color theory.

B. The students will increase their skills in drawing portraits.

Vocabulary:

Monochromatic, Tints, Shades

Materials:

Tempera paint: assorted colors with black and white
Paint trays
Brushes
12" x 18" tagboard

Process:

1. Monochromatic means one color. Tint is a color mixed with white. Shade is a color mixed with black. A monochromatic painting would consist of one color (e.g. red) and tints and shades created by mixing amounts of white and black with it.

2. Review feature placement. The face is an oval. The eyes are placed in the center (from top to bottom). The bottom of the nose is placed halfway down from the eyes to the chin. The mouth is placed halfway down from the nose to the chin. The ears are located on the side of the oval in the space even with the eyes and the bottom of the nose. The neck starts at the ears and never gets thinner than the thinnest part of the face.

3. Draw a face on the white paper. Use the paper vertically. Add a hat or hair decoration to the head. Add a neck and shoulders.

6. Before gluing objects down, outline edges and/or details with a marker. Also, create a surface (table, tablecloth, etc.), using the wallpaper or other paper, adding marker designs if desired. ***** You may also create a design on the wall space.

7. Glue objects down.

 ***** Note that objects in the front will be placed lower down on the page and the objects in the back will be placed higher on the page.

Evaluation:

A. Did the student understand the concept introduced?

B. Did the student show perspective through the use of overlapping?

C. Did the student draw realistic objects to the best of his/her abilities?

CONCEPT: PERSPECTIVE

GRADE: THIRD

LESSON: CUT PAPER STILL LIFE

Objectives:

A. The students will gain experience in showing perspective as objects overlap each other.

B. The students will expand their skills in drawing realistically, cutting and arranging a composition.

Vocabulary:

Still Life, Realism, Overlap, Perspective

Materials:

12" x 18" assorted construction paper.
Still life objects (plants, bottles, cans...anything will work)
Scissors
Glue
Construction paper scraps
Markers
Pencil
Wallpaper scraps

Process:

1. Set up a still life arrangement at each group or at each table. Keep it simple and pleasing to the eye from all directions. Have some objects overlap.

2. Realism shows objects drawn to look as much like them as possible.

3. Have students choose a viewpoint from which to draw.

4. On the scraps of construction paper, draw each still life object (the whole shape).

5. Cut these still life shapes out and arrange them on the paper according to their placement in the arrangement.

"I AND THE VILLAGE" by Marc Chagall *(cont.)*

7. Paint the areas of your abstracted profiles with these colors. Use the colors in their original hues and also mix them with white to produce tints. Mix them with black to produce shades. Paint in all areas of your painting. Black and white may also be used in their pure state.

8. You may choose to outline the painted areas with a marker when the paint is dry.

Evaluation:

A. Did the student understand the concept introduced?

B. Did the student handle the media to the best of his/her ability?

C. Did the student use creativity?

CONCEPT:	COLOR--TINTS & SHADES
GRADE:	THIRD
LESSON:	ABSTRACT PROFILES

Objectives:

A. The students will expand their knowledge of color study.

B. The students will gain further experience in abstracting a familiar subject.

Vocabulary:

Tint, Shade, Abstract, Profile, Hue

Materials:

12" x 18" white paper (or larger)

Tempera Paint: primary & secondary colors plus black and white

Paint trays
Newspaper
Brushes

Process:

1. Study your neighbor. How does the profile (side view) look different from the front view?

2. Choose either direction to work on your paper.

3. Draw 2 simple profiles on your paper. These may be placed in any arrangement (i.e. facing, back-to-back, etc.). Draw these large.

4. Draw 3 intersecting lines from one edge of the paper to another.

5. Each enclosed area is now a separate shape!

6. * You may wish to use a large sheet of tin foil for a paint tray. Place 3 colors of student's choice on the outer area of the paint tray, and 2 blobs of black and white on the center of the tray.

4. Roll ink out on the sheet of glass with the brayer. Roll brayer onto printing block. Carefully pick the print block up and move it to a clean surface area and lay a piece of paper on it. Rub the top of this paper with your hand. Remove paper from the print block. Lay print to the side to dry. Repeat printing process to produce desired number of prints.

Evaluation:

A. Did the student understand the concept introduced?

B. Did the student use texture successfully?

C. Did the student follow directions?

CONCEPT:	ANIMAL TEXTURE
GRADE:	THIRD
LESSON:	TEXTURED ANIMAL PRINT

Objectives:

A. The students will explore a new element of art.
B. The student will experience a new printmaking technique.

Vocabulary:

Texture, Print, Relief, Line, Brayer

Materials:

Foam meat tray (cut off edges)
Pencil
Block printing ink
Brayers
Square of glass
Thin markers
Assorted paper to print on

Process:

1. Talk about different types of textures that can be found on different animals (e.g. fins, quills, fur, scales, etc.). What type of lines could be used to describe these different textures? (e.g. straight, curved, overlapping, zig-zag, wavy, etc.).

2. Think of an animal with a lot of textures. Lightly sketch this animal onto the meat tray. For now, only worry about the basic shape or outline.

3. With a pencil, draw the texture on your animal. Press hard to make a groove into the meat tray as you draw. Go over any other previous details drawn in with marker. Your entire animal should be drawn into the meat tray so that it is indented. This is a relief type of printing block...areas are raised and others are indented.

"THE COMING STORM" by George Inness *(cont.)*

Evaluation:

A. Did the student understand the concept introduced?

B. Did the student handle the media to the best of his/her ability?

C. Did the student project a positive attitude?

CONCEPT: SKY LANDSCAPE

GRADE: THIRD

LESSON: WATERCOLOR SKY PAINTING

Objectives:

A. The students will be exposed to a new painting technique.

Vocabulary:

Landscape, Wet on Wet, Watercolor

Materials:

Watercolor paper or white drawing paper
Watercolors
Brushes: Large and Medium size
Newspaper
Water containers

Process:

1. Lay paper on newspaper.

2. Paint the top 2/3 of the paper with water using a large brush. While this is still wet, you will paint on it. If it dries, wet it with water.

3. Paint the watercolors on in horizontal brushstrokes that are straight, curvy, wavy, or broken. A broken brushstroke line may be filled in with a different color. You may use one or a combination of these brushstrokes.

4. Colors will mix and bleed. Try to work with diluted colors first and then the darker shades of that color. You may always make a color darker, but you cannot make it lighter!

5. Experiment with different sizes of brushes.

6. Let dry.

7. Paint a landscape at the bottom of your painting. The sky will take up more than half of the space in your picture. Be creative!

5. For a final project, complete a contour line drawing with markers. Remember correct proportions for the figure.
 *If your students do well with this, have them draw several different figures arranged randomly on a larger sheet of drawing paper.

Evaluation:

A. Did the student understand the concept introduced?

B. Did the student complete this project to the best of his/her ability?

C. Did the student show creativity?

CONCEPT:	FIGURE ART
GRADE:	THIRD
LESSON:	CONTOUR LINE FIGURE DRAWING

Objectives:

A. Students will expand their skills in figure drawing.

B. Students will experience drawing with contour lines.

Vocabulary:

Contour Line, Proportions

Materials:

9" x 12" white paper--several for each student
Thin markers

Process:

1. Have a model pose for the class.

2. Look at the outline of the model's body and clothes. A contour line drawing is drawing the outside characteristics that make up the object you are drawing. In this case you will be drawing the body, folds of the clothes as they drape around figure, folds in the skin as parts are bent, hair and other simplified details.

3. A contour line is done best when you do not pick the pencil up off the paper. Try to keep your line going...you may backtrack lines to get to another area.

4. Practice several different poses, 5-8 minutes each. Practice drawing with both pencil and markers. Markers allow for a more continuous line since you cannot erase.

"WEDDING DANCE" by Pieter Brueghel the Younger *(cont.)*

4. Fill your entire paper by drawing large objects and figures you see through the view-finder. You shouldn't have to add other objects to the paper because you drew these too small.

5. Color in with colored pencils and outline with the markers.

Evaluation:

A. Did the student understand the concept introduced?

B. Did the student fill up his/her entire paper?

C. Did the student use the materials properly?

CONCEPT: GENRE

GRADE: THIRD

LESSON: CLASSROOM SCENE

Objectives:

A. Students will be exposed to a new subject matter.

B. Students will create their own modern day genre drawing.

Vocabulary:

Genre, Ordinary, View-finder

Materials:

2" x 5" strips of paper--4 for each student
12" x 18" white drawing paper
Colored pencils
Thin markers
Stapler or tape

Process:

1. Genre is a scene of ordinary people doing ordinary things. These people could be peeling potatoes, doing laundry, working in the garden, taking a bath, etc. Think of this as a "snap-shot" of ordinary people that you could take with your camera.

2. Make your imaginary camera or view-finder by stapling or gluing 2 strips of paper to form an "L" shape. Do the same with the other two strips. Use both hands to hold these "L" shapes as a frame. Look around the room to find something interesting to draw. Slide the "L" shapes up and down, right and left, to frame the scene you would like to draw. Tape or staple your frame into the shape desired so you can use it to look at your scene again when you need to.

3. Draw the scene that you see through the view-finder on your drawing paper. (If everyone in your room is looking around the room with a view-finder, try to draw them working or in some other natural position!)

"APPLES AND ORANGES" by Paul Cézanne *(cont.)*

4. Take both the green and purple papers and stack them on top of each other. Draw several circles to create a cluster of grapes. Cut these out at the same time.

5. Outline the orange pumpkin shape with the orange chalk as shown. Now go over the thick areas with brown chalk. Use the chalk as a flat and thick line and not as a sharp, dark line.

6. On the apple, outline with the red chalk. Have a very thin red line on the right side and a wider line on the left side and bottom. Now add some brown chalk on the top of the red in these areas.

7. On the pear, outline the shape with brown chalk as shown. Do in the same manner as the red on the apple. Now, add a little bit of light green in the area shown.

8. On the grape sections, use the green chalk on the green shape, and the purple on the purple shape. Draw circles inside the entire shape with the chalk. On the left and bottom side of each grape circle, draw a brown "U" shape in chalk.

9. Arrange the objects on the black paper and glue in place. You may wish to add some leaf shapes to your composition.

10. Spray with a fixative to keep the chalk from smearing.

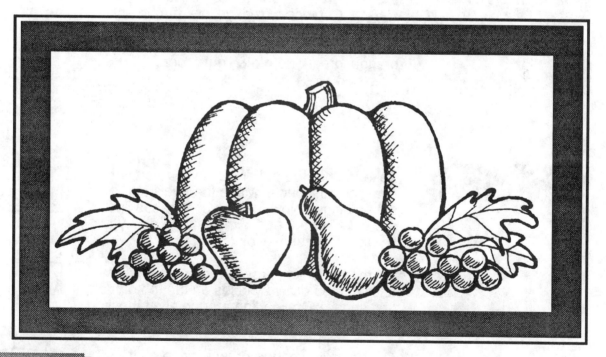

Evaluation:

A. Did the student understand the concept introduced?
B. Did the student use geometric shapes to construct the shapes?
C. Did the student use chalk shading to show roundness in these shapes?

MASTERPIECE: "APPLES AND ORANGES" *by Paul Cezanne*

CONCEPT: SHAPE

GRADE: THIRD

LESSON: PAPER STILL LIFE

Objectives:

A. Students will produce a paper still life composition using geometric shapes.

B. Students will create rounded forms from flat shapes through the use of chalk shading.

Vocabulary:

Shape, Form, Geometric, Shading

Materials:

One each 12" x 18" black construction paper, 9" x 12" orange construction paper, 4 1/2" x 6" piece of red, yellow, purple and green construction paper
Small pieces of colored chalk: brown, red, orange, green, purple & light green.
Scissors
Glue
Pencil

Process:

1. Take the orange paper. Draw 3-4 vertical ovals on this piece. Make the ovals stand side-by-side. Now make a continuous line around all of the ovals, this should give you a pumpkin shape. Cut it out.

2. On the red piece, draw a rectangle shape as shown, then draw 2 circles on the top of that first shape. Draw a line around all of these shapes to make an apple shape. Cut it out.

3. On the yellow paper, draw a circle on the bottom half. Then draw an oval standing on the circle. Draw a line around these shapes to make a pear shape. Cut out.

"STARRY NIGHT" by Vincent van Gogh (cont.)

6. From the black paper, cut a landscape silhouette. Try trees, buildings, landmarks, etc. Glue this onto the bottom of your dry painting.

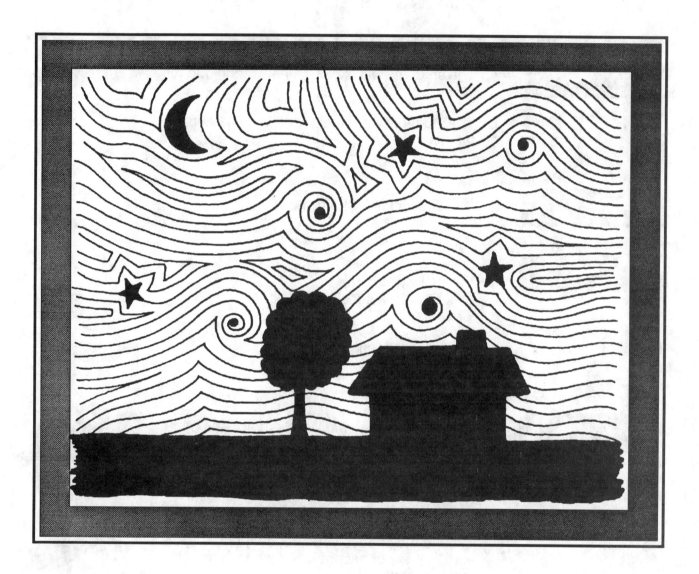

Evaluation:

A. Did the student understand the concept introduced?

B. Did the student show creativity in his/her work?

C. Did the student use the media correctly?

MASTERPIECE: "STARRY NIGHT" *by Vincent van Gogh*

CONCEPT: LINE AND MOVEMENT

GRADE: THIRD

LESSON: CRAYON SKY RESIST

Objectives:

A. The students will explore a new technique for color.

B. The students will experiment with line and movement.

Vocabulary:

Resist, Line, Movement

Materials:

Newspaper
12" x 18" white paper
6" x 18" black construction paper
Crayons
Glue
Diluted black tempera paint
Paper towels

Process:

1. Start by drawing swirls, curls, stars and other sky patterns on the top 2/3 of the white paper. Draw these lines with bright colors of crayon--use white also! Press hard while drawing with the crayons.

2. Continue drawing more lines and patterns around the shapes you already have. Leave a small space of paper showing between any two crayon marks.

3. Fill up entire 2/3 of paper with your sky design.

4. Place drawing on newspaper and paint with diluted black paint mixture. Start at the top and drag the brush across from left to right. Get more paint and continue one row at a time.

5. Dab off excess black paint mixture with the paper towels. Let dry.

"BEASTS OF THE SEA" by Henri Matisse *(cont.)*

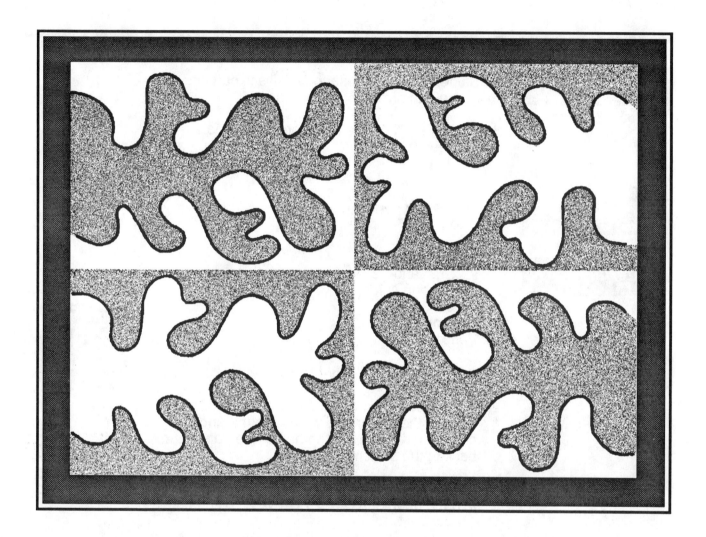

Evaluation:

A. Did the student understand the concept introduced?

B. Did the student show creativity in creating their organic shape?

C. Did the student arrange shapes to create a successful composition?

CONCEPT: SHAPE

GRADE: SECOND

LESSON: CUT OUT PAPER PATTERNS

Objectives:

A. Students will increase their skills in cutting, gluing and arranging a composition.

B. Students will create a design using organic shapes.

Vocabulary:

Organic, Curved Lines, Diagonal

Materials:

9" x 12" and 12" x 18" construction paper of contrasting colors
Glue
Scissors
Pencil

Process:

1. Fold the 9" x 12" paper in half like a book.

2. Draw a curved line that starts on the bottom edge of the paper and winds around and curves upward to the top half of the paper and back to the bottom edge.

3. Cut on this line while the paper is still folded into the double thickness. Save all pieces.

4. Arrange the two pieces that are cut out onto the larger paper which has been folded into fourths. Place one in each corner that is opposite diagonally.

5. Open the 9" x 12" folded paper and cut on the fold.

6. Arrange these two pieces in the remaining two diagonal corners.

7. Glue desired arrangements in place.

6. Let dry while you cut out the shapes for the object that is "up-close" in your picture.

7. Use the scissors to cut a shape out of the darker and brighter colors of tissue paper. (Don't draw on the tissue...just cut out your shape without pre-drawn lines!)

8. Good motifs would be: plants, flowers, butterflies.

9. After the parts of your motif are cut out, glue it onto the paper using the same mixture and method as before. Colors may bleed and smear a little but the perspective will still show since the dark, bright colors are in the front and the lighter colors are in the back.

10. Let dry completely.

Evaluation:

A. Did the student understand the concept introduced?

B. Did the student handle the media correctly?

C. Did the student show individual creativity?

MASTERPIECE: "CENTRAL PARK" *by Maurice Pendergast*

CONCEPT: PERSPECTIVE

GRADE: SECOND

LESSON: TISSUE PAPER OVERLAYS

Objectives:

A. Students will gain experience in showing perspective in their work.

B. Students will be exposed to a new media and method.

Vocabulary:

Overlay, Value Perspective, Transparent

Materials:

12" x 18" white paper
Mixture: 1/2 glue and 1/2 water
Brushes--medium to large
Assorted tissue paper: 12" in width
Scissors

Process:

1. Value perspective shows objects that are close to us in full, bright colors. Objects that are farther away are lighter and not as bright in color.

2. Discuss possibilities for a theme...stress creativity.

3. Choose the light and pale shades of tissue paper. Tear strips of tissue. You may tear 2-3 layers of different colors at one time.

4. Position the white paper lengthwise in front of you. Starting at the top, paint the glue mixture on the paper. Lay down a torn piece of tissue and then paint over it.

5. Continue placing more light colors of tissue onto the white paper. Overlap the tissue paper that is already in place. Continue to the bottom of the paper. Colors will look transparent as they are overlapped onto other colors.

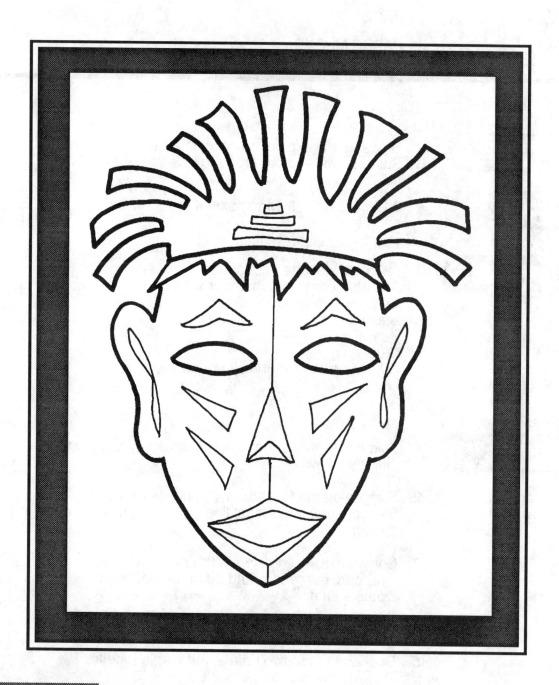

Evaluation:

A. Did the student understand the concept introduced?

B. Did the student use creativity in this project?

C. Did the student complete the project?

MASTERPIECE: "SENECIO-HEAD OF A MAN" *by Paul Klee*

CONCEPT:	2-DIMENSIONAL TO 3-DIMENSIONAL
GRADE:	SECOND
LESSON:	PAPER MASKS

Objectives:

A. Students will explore creating in 2-demensions.
B. Students will explore creating in 3-demensions.

Vocabulary:

2-Dimensional, 3-Dimensional

Materials:

12" x 18" assorted construction paper
Assorted construction paper scraps
Scissors
Stapler
Pencil
Glue
Other Scraps: Material, yarn, paper, etc.

Process:

1. Fold the 12" x 18" sheet of construction paper in half the tall way.

2. Starting on the fold about 4-5 inches down from the top, draw a diagonal line up to the top edge of the paper.

3. Continue down the side of the paper to draw a forehead, ear, and round off at the bottom to create a chin.

4. Cut out this shape.

5. Overlap the top two points and staple together. This will make your mask 3-D.

6. Add pieces of scrap materials to the mask for the features plus any other decorations. Glue or staple into place.
 *Fold scrap paper in half and cut two identical shapes at the same time. Glue one on each side of the mask.

"I SAW THE FIGURE FIVE IN GOLD"
by Charles Demuth *(cont.)*

6 Give each student a paint tray with blue, green and violet tempera paint. Paint the background areas with these colors. Mix them together to create new colors: blue-violet and blue-green.

7. Let dry.

8. Paint number with yellow tempera paint. The cool colors will look as if they recede (go back into the picture). Yellow is a warm color, it will look as if it advances (pops out or comes forward).

9. Let dry, then display.
 *If your students have difficulty making straight paint edges...have them outline the entire design when it is dry with a thick black marker. This will hide jagged painted edges and also make the colors stand out!

Evaluation:

A. Did the student understand the concept introduced?

B. Did the student use the cool colors effectively?

C. Did the student show creativity and complete the painting?

MASTERPIECE: "I SAW THE FIGURE FIVE IN GOLD"

by Charles Demuth

CONCEPT: COOL COLORS
GRADE: SECOND
LESSON: PAINTED NUMBERS

Objectives:

A. Students will gain further knowledge of color theory.

B. Students will create a painting using the cool colors.

Vocabulary:

Cool Colors, Recede, Advance

Materials:

12" x 18" tagboard
Pencil
Eraser
Paint tray
Brushes
Tempera paint:
Blue, Green, Violet & Yellow

Process:

1. Draw a large numeral of your choice in the center of your paper. This is your skeleton number.

2. Draw around the skeleton number on both sides to turn the skeleton into a solid shape. Try to stay the same distance away from the skeleton all the way around.

3. Erase the skeleton line.

4. Starting at the edge of the number, draw lines off the edge of the paper. Space these out around the number.

5. Talk about the cool colors. They are blue, green and violet. They represent cool, calm and peaceful subjects such as a lake, green lawn, etc.

"SUNFLOWERS" by Vincent van Gogh *(cont.)*

5. Paint the background first, then the table. Paint the flowers and vase next. Try mixing the warm colors to create various colors on the warm side of the color wheel. Warm colors represent hot, energetic objects: sun, fire, etc. Warm colors tend to advance or come forward.

6. Your painting is a study of warm colors but you may also use some green as Van Gogh used to represent stems and leaves.

Evaluation:

A. Did the student understand the concept introduced?

B. Did the student handle materials to the best of his/her ability?

C. Did the student show individual creativity?

CONCEPT:	WARM COLORS
GRADE:	SECOND
LESSON:	FLOWER PAINTING

Objectives:

A. Students will be exposed to a new technique of painting.

B. Students will increase their knowledge of color theory.

Vocabulary:

Warm Colors, Impasto

Materials:

12" x 18" tagboard
Tempera paint:
Oranges, Yellows, Reds, & Greens
White powdered laundry detergent

Process:

1. Van Gogh painted with strokes of paint. This style is called "impasto." Mix a small amount of detergent with each color of paint.

2. Start by drawing a vase on the paper. Place this on the bottom half of the paper keeping the bottom of the vase from touching the bottom edge of the paper.

3. Add a horizontal line so your vase sits on a surface.

4. Create your own inventive flowers. Draw them large. Add stems and leaves.

"DON MANUEL OSORIO" by Francisco Goya *(cont.)*

Evaluation:

A. Did the student understand the concept introduced?

B. Did the student show correct proportions to the best of his/her abilities?

C. Did the student complete the project?

CONCEPT:	FIGURE ART
GRADE:	SECOND
LESSON:	FIGURE PORTRAIT WITH A PET

Objectives:

A. Students will increase their skills in drawing the human figure.

B. Students will use their creativity to complete a personal figure portrait.

Vocabulary:

Figure portrait

Materials:

12" x 18" white paper
Crayons, markers or colored pencils

Process:

1. Review correct placement of parts of the body.

2. Draw a full figure portrait of yourself.

3. Add your favorite pet or pets to the picture.

4. Color in the entire picture.

5. Stress correct proportions, not only on the body, but also the size relationships of the pets to the figure.

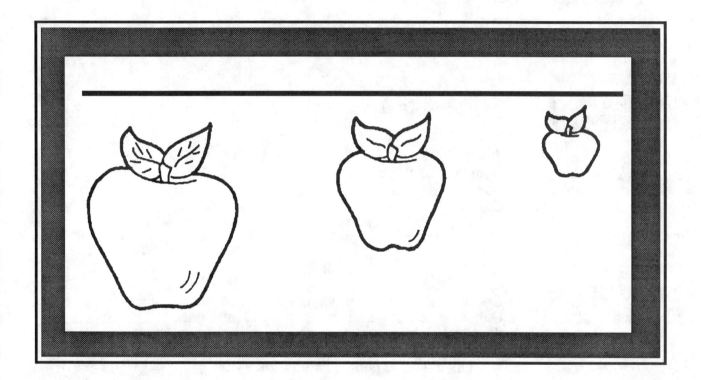

A. Did the student understand the concept introduced?

B. Did the student use materials properly?

C. Did the student complete the project?

CONCEPT: PERSPECTIVE

GRADE: FIRST

LESSON: LARGE VS. SMALL

Objectives:

A. Students will become aware of size relationships to show perspective in objects.

B. Students will increase their skills in drawing, cutting and gluing.

Vocabulary:

Perspective, Repetition, Size

Materials:

Construction paper
Scissors
Glue
12" x 18" background paper
6" x 18" background paper

Process:

1. Select a background and a foreground paper. Glue foreground paper to background paper so they line up at the bottom.

2. Discuss the word perspective. Stress how objects get smaller in the distance.

3. Discuss the word repetition. You will be using one object in 3 different sizes.

4. Think of an object and draw it large, medium and small. Cut them out and glue them onto the foreground paper.

 NOTE:
 The largest object is placed at the bottom area of the paper...the medium size is placed up higher on the paper...and the small size is placed up even higher than the other two.

5. For an added feeling of perspective, draw 3 lines for details on the large object, 2 lines on the medium object and one line on the small object.

"PEOPLE AND DOG IN SUN" by Joan Miro *(cont.)*

Evaluation:

 A. Did the students understand the concept introduced?

 B. Did the student use the correct procedure and technique?

 C. Did the student complete the project?

MASTERPIECE: "PEOPLE AND DOG IN SUN" *by Joan Miro*

CONCEPT:	ABSTRACT
GRADE:	FIRST
LESSON:	OVERLAPPED ABSTRACTIONS

Objectives:

A. Students will experience new techniques to improve their drawing skills.

B. Students will gain further enrichment in abstracting objects.

Vocabulary:

Abstract, Color, Shape

Materials:

9" x 12" white drawing paper
Ruler
Crayons

Process:

1. Draw an object on the paper. Add details to complete the drawing.

2. Draw a 3 inch grid on top of your drawing.

 NOTE:
 Teachers may have to help draw 3 inch marks on the edges for the students to use to draw straight lines with a ruler.

3. Choose only 3-4 colors of crayons. You will color in every "enclosed" area. You should change colors when you come to a line. Try to mix colors up so you do not have the same color side by side.

4. Outline all lines (object & grid) with a black crayon.

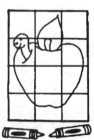

"LA GRANDE JATTE" by Georges Seurat *(cont.)*

Evaluation:

 A. Did the student understand the concept introduced?

 B. Did the student handle the media well?

 C. Did the student show individual creativity?

CONCEPT: ARTIST STYLE
GRADE: FIRST
LESSON: POINTILLISM

Objectives:

A. Students will be introduced to a new painting technique.

B. Students will gain further enrichment in the study of color.

Vocabulary:

Primary, Secondary, Pointillism

Materials:

Fingerpaint--primary colors
Half-sheet of fingerpaint paper
Sponges

Process:

1. Wet paper with sponge. Wipe off excess water.

2. Use index finger to create a picture using only dots. A good motif could be a simple animal, flower or plant.

3. Place dots of two primary colors close together in the same area. This will create the illusion of mixing to make the secondary colors.

4. Use the pointillism technique on the entire sheet of paper.

"WHEN DO YOU MARRY?" by Paul Gauguin *(cont.)*

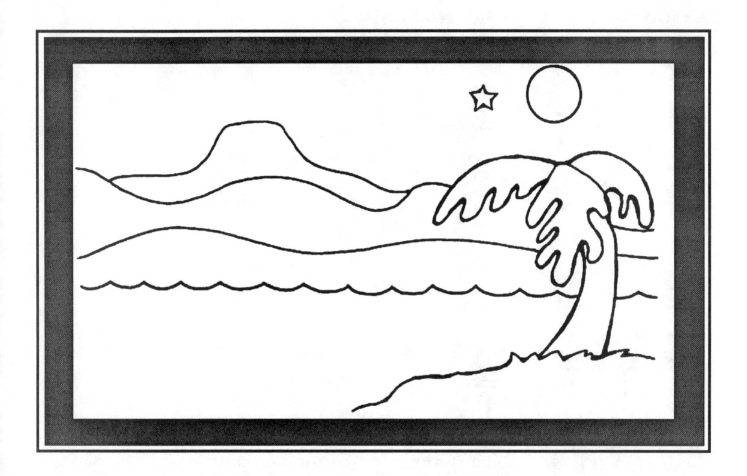

Evaluation:

A. Did the student understand the concept introduced?

B. Did the student succeed in mixing the secondary colors?

C. Did the student use his/her creativity to create his/her own painting with a Gauguin influence?

MASTERPIECE: "WHEN DO YOU MARRY?" *by Paul Gauguin*

CONCEPT: SECONDARY COLORS
GRADE: FIRST
LESSON: TAHITIAN LANDSCAPE

Objectives:

A. Students will review the primary colors.

B. Students will experience using secondary colors.

C. Students will create a Gauguin-influenced landscape painting.

Vocabulary:

Primary, Secondary, Tahitian, Landscape

Materials:

12" x 18" tagboard
Pencils
Tempera paint--Red, Yellow and Blue
Paint tray for mixing

Process:

1. Draw a landscape that could be seen on a Tahitian island. Draw a foreground and background.

2. Draw a Tahitian figure, building, tree or other object in the foreground.

3. Using only red, blue and yellow paint, mix to get orange, green, and purple. Paint your Tahitian landscape using the primary colors (red, yellow and blue) plus the secondary colors that you mix (orange, green and purple).

NOTE:
Notice how Gauguin used these same colors.

"BALLET SCHOOL" by Edgar Degas *(cont.)*

5. On another paper practice drawing a ballerina that will be large enough to fill the paper you printed with the sponge.

 NOTE:
 Some children may want to draw a male ballet dancer.

 DAY TWO:

1. Choose your best practice sketch and lightly draw this on the printed paper with a pencil.

2. Outline drawing with a thin painted line using black tempera. Let dry.

3. Use oil pastels to color in the figure.

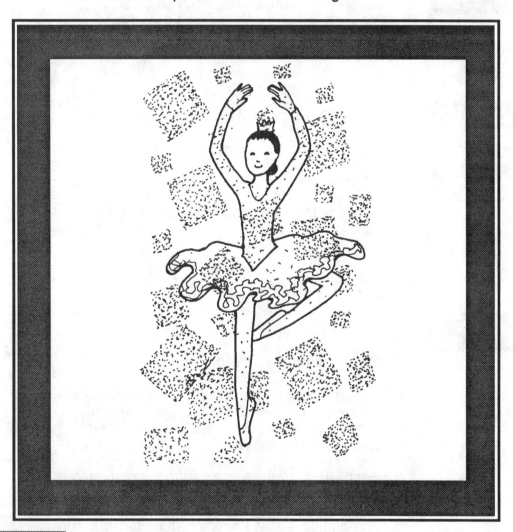

Evaluation:

A. Did the student understand the concept introduced?

B. Did the student show proper technique for application of materials?

C. Did the student use creativity to complete his/her project?

CONCEPT: FIGURE ART

GRADE: FIRST

LESSON: BALLERINA PAINTING (2 Day Project)

Objectives:

A. Students will be introduced to the use of several techniques to complete a project.

B. Students will experience completing a painting influenced by the style of a Degas.

Vocabulary:

Figure, Ballerina, Pastel, Form

Materials:

Tempera paint--4 pastel colors and black
18" x 24" construction paper (dull colors)
Sponges (squares held by clothespins)
Newspaper
Pencils
Oil pastels
Pie plates
Scratch paper

Process:

DAY ONE:

1. Discuss Degas' painting.

2. Set up a station for each of the four colors of tempera paint. Place paint in pie plate and allow a few sponges for each color. Cover area with newspapers.

3. Each student will go from station to station to print all four colors.

4. To print, dip sponge in paint, dab off excess on side of plate, stamp a few times on newspaper until it makes a "lacy" print. Stamp this lacy print all over the 18" x 24" paper. Stamps should be "lacy" and light in color. Overlap stamps as you go to all four stations. Set aside to dry.

"THE GOLDFISH" by Paul Klee *(cont.)*

Evaluation:

A. Did the student understand the concept introduced?

B. Did the student use the media correctly?

C. Did the student show creativity in his/her work?

CONCEPT:	ANIMAL
GRADE:	FIRST
LESSON:	PASTEL RESIST

Objectives:

A. Students will experience using colors and contrast in their work.

B. Students will be exposed to the resist paint technique.

Vocabulary:

Color, Resist, Contrast

Materials:

Oil pastels
12" x 18" white paper
Black tempera paint thinned with water
Wide flat brushes
Newspapers

Process:

1. Draw a fish scene with the pastels. Press hard as you color in. Bright colors will work the best.

2. Place drawing on newspaper.

3. Paint a wash:
 --dip a brush in diluted black paint.
 --drag the brush from one side to the other across the top.
 --dip again, slightly overlap and paint across the second row.
 --continue to the bottom.
 Let dry.

4. *You may wish to dab the wet painting with paper towels if the layer of paint is too thick for the pastels to show through.
 NOTE:
 Black India ink or watercolors may be substituted for black tempera if necessary.

"THE TORN HAT" by Thomas Sully *(cont.)*

Evaluation:

A. Did the student understand the concept introduced?

B. Did the student use materials properly?

C. Did the student use creativity to complete his/her project?

CONCEPT: PORTRAIT

GRADE: FIRST

LESSON: FACE DRAWING

Objectives:

A. Students will experience drawing facial features in correct proportions.

B. Students will be exposed to methods to help improve their drawing skills.

Vocabulary:

Portrait, Proportions, Placement, Balance

Materials:

9" x 12" fleshtone paper
Pencil
Crayons
Construction paper scraps
Scissors
Glue

Process:

1. Fold paper in half, and then in half again. Open up.

2. Draw a large oval that touches all four points on the edge at each fold crease.

3. Draw two small egg shapes for the eyes on the fold. Draw "U" shapes inside each egg and darken in a pupil in the center.

4. Draw a nose from the eyes halfway to the chin. Draw only one side and the bottom of a nose.

5. The mouth is placed halfway between the bottom of the nose and the chin. The mouth is as wide as the pupil in the eyes. Try to draw the mouth to show both lips.

6. Cut out face. Add paper hair; glue in place.

7. Color in eyes, mouth and other details. Add a paper hat, ribbon or flower.

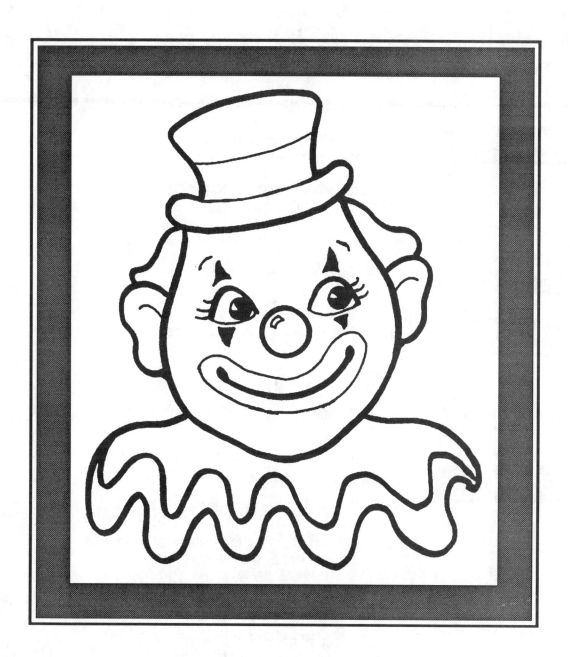

Evaluation:

A. Did the student understand the concept being introduced?

B. Did the student follow instructions and attempt to master the procedure to his/her best ability?

C. Did the student complete the project?

MASTERPIECE: "SEATED HARLEQUIN" *by Pablo Picasso*

CONCEPT: FEATURE PLACEMENT

GRADE: FIRST

LESSON: TEMPERA CLOWN

Objectives:

A. Students will gain experience in using correct placement of facial features.

B. Students will explore mixed media to complete a project.

Vocabulary:

Symmetry, Expression, Color

Materials:

12" x 18" black construction paper
White tempera paint
Chalk
Crayons (or colored chalk)
Paint brush
Pictures of clowns

Process:

1. Look at pictures of clowns.

2. Position your paper the tall way.

3. Using the chalk, draw the outline of a clown's head...add a hat and a wavy collar.

4. Paint 2 layers of white paint over the clown (one vertically and one horizontally). Let dry.

5. Talk about symmetry...draw the same features on each half of the clown.

6. Draw designs with crayons on top of the paint. Color areas in with a thick layer of crayon. Leave some areas white. Use black crayon to outline each of the different features.

7. The black paper will frame your clown. It is ready to be displayed.

"COMPOSITION IN RED, YELLOW & BLUE"

by Piet Mondrian *(cont.)*

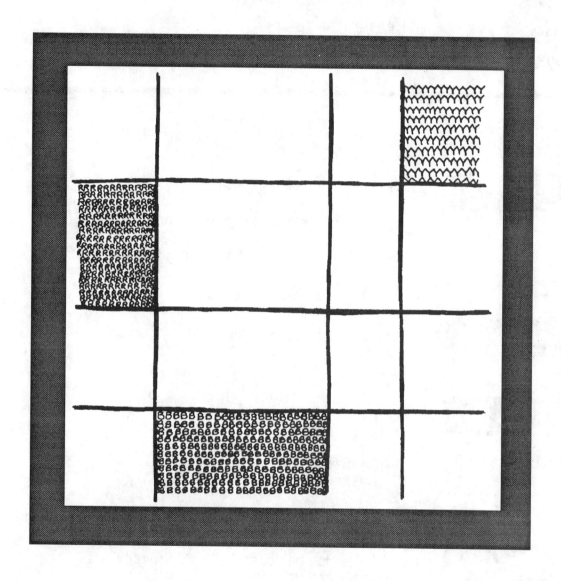

Evaluation

A. Did the student understand the concept introduced?

B. Did the student use creativity to paint the colors in an interesting composition?

C. Did the student use the media properly?

MASTERPIECE: "COMPOSITION IN RED, YELLOW & BLUE"

by Piet Mondrian

CONCEPT:	PRIMARY COLORS & LINE
GRADE:	KINDERGARTEN
LESSON:	BLACK GLUE LINE COMPOSITION

Objectives:

A. Students will be introduced to the primary colors.

B. Students will experience a mixed-media project.

C. Students will follow the style and technique of a famous painter.

Vocabulary:

Primary Colors, Line, Composition, Vertical, Horizontal

Materials:

Black tempera & glue mixture (1/2 & 1/2) in squeeze bottles

White poster paper, 18" x 18"
Tempera paint: Red, Yellow & Blue
Brushes

Process:

1. With the glue bottle, draw 2 or 3 straight lines vertically and horizontally on the white paper.

2. Let dry overnight.

3. Choose one area to paint red, one to paint blue, and one to paint yellow. Try to have these spaced out to create an interesting composition.

Evaluation:

A. Did the student understand the concept being introduced?

B. Did the student show individual creativity to complete the project?

C. Did the student follow instructions and complete the project?

MASTERPIECE: "BLUE ATMOSPHERE" *by Helen Frankenthaler*

CONCEPT:	ABSTRACTION
GRADE:	KINDERGARTEN
LESSON:	TISSUE PAPER BLEED

Objectives:

A. Students will experience a new media color.

B. Students will be exposed to a new painting technique.

C. Students will use their own creativity to complete their project.

Vocabulary:

Abstract, Color, Form, Shape, Line

Materials:

Scraps of tissue paper torn into hand-size pieces
12" x 18" white paper
Large soft brushes
Water containers
Black markers

Process:

1. Paint an area of the paper with water.

2. Lay tissue on wet paper and brush over it with water.

3. Lay another sheet of tissue on the paper and continue to fill most of the paper.

4. Remove tissue scraps. The colors should have bled and mixed together.

5. Let the paper dry.

6. Outline inventive shapes and patterns with a black marker. A tissue paper bleed may lend itself to be a landscape, animal, person, or just a random pattern.

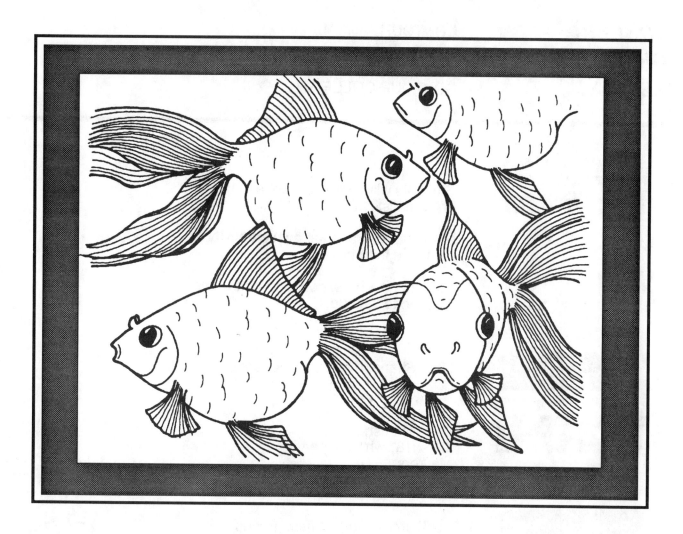

Evaluation:

A. Did the student understand the concept being introduced?

B. Did the student attempt to handle the technique of contour line effectively?

C. Did the student show individual creativity to complete the project?

CONCEPT:	CONTOUR ANIMAL
GRADE:	KINDERGARTEN
LESSON:	CONTOUR GOLDFISH

Objectives:

A. Students will gain experience in trying to draw realistically.

B. Students will use their own creativity to complete their project.

C. Students will be exposed to a new line drawing technique.

Vocabulary:

Line, Shape, Contour, Overlapping, Detail

Materials:

Live Goldfish
12" x 18" white paper
Markers

Process:

1. Look at the live goldfish. Focus on the outside (contour line) of the fish. Draw the contour edge of the fish in the air with your finger.

2. Now, draw this fish on your paper with the marker.

3. Draw another fish in another position.
 NOTE:
 For a successful drawing, have the students draw the objects so they touch each other, overlay and "bleed off" the edges of the paper.

4. Continue to draw fish until the paper is filled.

5. Add a few lines to show fins and other features on the fish.

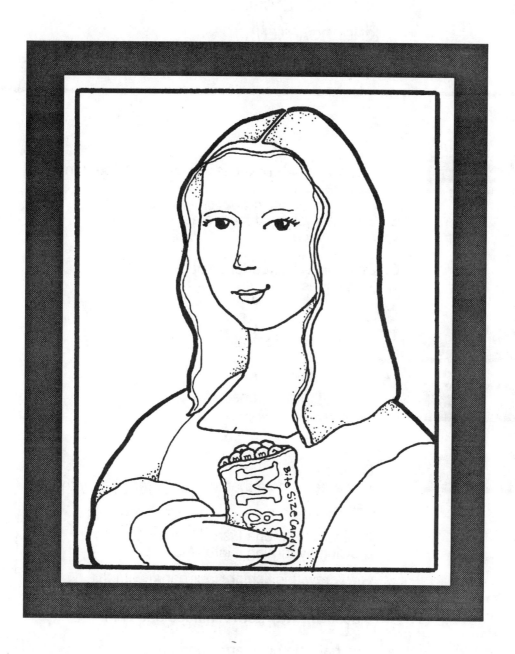

Evaluation:

A. Did the student understand the concept introduced?

B. Did the student use correct feature placement in his/her drawing?

C. Did the student show individual creativity to modernize his/her replica of this masterpiece?

CONCEPT: FEATURE PLACEMENT

GRADE: KINDERGARTEN

LESSON: MODERN MONA LISA

Objectives:

A. Students will be exposed to correct placement of facial features.

B. Students will produce a creative replica of a masterpiece.

C. Students will experience portrait drawing techniques.

Vocabulary:

Portrait, Texture, Value

Materials:

12" x 18" white paper
Crayons

Process:

1. Draw an oval.
 Add a neck (note that the neck starts up by the ears).

2. Look at the "Mona Lisa." Complete your drawing by turning it into "Mona Lisa."

3. Center eyes in middle of oval. Nose is placed 1/2 way between eyes and chin. Mouth is placed 1/2 way between nose and chin.

4. Add hair, clothing, arms and hands.

5. Put something modern in her hand!--candy, pop, ice cream cone, etc.

6. Color.

Evaluation:

A. Did the student understand the concept introduced?

B. Did the student use creative shapes for the flowers?

C. Did the student use the materials properly?

CONCEPT:	SHAPE
GRADE:	KINDERGARTEN
LESSON:	PAPER FLOWER BOUQUET

Objectives:

A. Students will experience a new method to cut paper.
B. Students will create a pleasing compositional arrangement.

Vocabulary:

Shape, Cut Edge, Torn Edge, Composition

Materials:

Assorted construction paper
12" x 18" white paper
Glue
Scissor
Pencil

Process:

1. Trace hand, wrist and part of the forearm on fleshtone construction paper.

2. Cut out with a pair of scissors.

3. Look at the Picasso. Use assorted colors of construction paper to tear out shapes. Invent your own kind of flower!

4. Cut out some stems, tear some leaf shapes. Lay the flowers off to the side for now.

5. Fold the cut hand shape at the knuckle joint on all fingers and thumb.

6. Glue fingers down to the paper. Slip in stems and glue down wrist and arm.

7. Glue down stems. Add the flowers and leaves; glue them in place.

"COMPOSITION STORM" by Wassily Kandinsky *(cont.)*

A. Did the student understand the concept introduced?

B. Did the student show creativity in his/her work?

C. Did the student use the materials properly?

MASTERPIECE : " COMPOSITION STORM" *by Wassily Kandinsky*

CONCEPT: COLOR & COMPOSITION

GRADE: KINDERGARTEN

LESSON: WATERCOLOR & CRAYON ABSTRACTION

Objectives:

A. Students will experience the use of ordinary shapes to make a composition.
B. Students will be exposed to techniques to create an abstract design.
C. Students will use their imagination to create an abstract project.

Vocabulary:

Abstract, Line, Brushstroke, Mood, Overlap

Materials:

12" x 18" white paper
Objects to trace (cans, tools, shoes, rocks, etc.)
Crayons - All colors--even white
Watercolors
Large brushes

Process:

1. Use crayons to trace shapes all over the white paper. Press hard with the crayon. These shapes may be in different colors of crayons and may overlap onto other shapes. Fill up most of the paper.

2. Draw lines, patterns and designs into the areas you have traced onto the paper. Do not color in these areas, only draw lines, dots, stripes, or other patterns.

3. Use the large brushes to paint watercolors over different areas of your drawing. The crayon should resist the watercolors and show through the areas you paint.

4. Continue to paint until all areas of the white paper are painted.

NOTE:
Choose different colors to paint at random on your design; they do not have to be painted within the drawn lines.

"Mural" by Jackson Pollock *(cont.)*

Evaluation:

A. Did the student understand the concept introduced?

B. Did the student use the drip techniques properly?

C. Did the student show individuality in his/her painting?

CONCEPT:	LINE
GRADE:	KINDERGARTEN
LESSON:	DRIP PAINTING

Objectives:

A. Students will be exposed to a different style of painting.

B. Students will experience painting in this style by completing an individual project.

Vocabulary:

Abstract, Line, Color

Materials:

18" x 24" Newsprint (or Butcher Paper)
Newspaper
Paper cups
Tempera paint
Cornstarch
Old pie plates

Process:

NOTE:
You may wish to set up work stations for this project and take turns.

1. Add a little cornstarch to the paper cups filled with the colors of paint. The paint should be thick like cream.

2. Place newsprint on newspaper.

3. Punch holes in the bottom of the cups with a pencil. Drip colors onto your newsprint. Try drips, swirls, spots, dribbles, slow and fast movement, up and down movement.

4. Place cup in pie plate and use a different color.

5. Continue until your painting is full of color and all kinds of drips. Let dry.

Introduction

Masterpiece of the Month is an art program for grades K-5. It is designed to be taught by the regular classroom teacher. Each lesson is based on an art history approach which incorporates learning about art as well as doing art.

The ideal way to present a lesson is to display the art reproduction that is related to that lesson as well as some information about each artist. One print per month can be displayed on an art bulletin board or in an art corner throughout the year. During the month, the students will complete an activity. The activity includes scanning (looking at) the reproduction for that month, learning key words, concepts, and some art history information such as period, style, artist's name, nationality, and favorite subjects. The students will also complete a production activity from the lessons in this book.

The lessons focus on the following elements of design: line, color, texture, shape, space, and form. The main concepts and skills that are sequenced throughout all the grade levels are shown below.

Sequence of Concepts and Skills

	Color	Figure	Portrait	Animals	Perspective	Abstraction
K	Primary	Proportions	Placement	Contour	Fore-Background	Blobs
1	Secondary	Moveable Joints	Placement	Pastel Resist	Large vs. Small	Overlap
2	Warm-Cool	Self Portrait	Line	Paper Batik	Overlapping	2-D to 3-D
3	Tints & Shades	Contour	Values	Print	High-Low	Profile
4	Complements	Gesture	Decorative Background	Textured Ink	Values	Round Art
5	Analogous	Repeated	Profiles	Decorative	Details	Unrealistic Colors

The activities use a wide variety of common art supplies found in most schools: crayons, chalk, tempera paint, construction paper, glue, watercolors, markers, etc.

Students and teachers alike will benefit from art lessons that involve more than just making art. By looking at famous paintings by well-known artists, students can learn techniques and styles and how they can be used effectively in a work of art. By looking at and understanding famous art, students will be able to make better judgments about their work and hopefully have more success with their art work.

This type of art history approach can also be extended across the curriculum. Students may be asked to write a story about an artist, study the country that the artist came from or dress up as that artist or as a person in their painting!

Resources

Art Reproductions
Shorewood Find Arts Reproduction, Inc.
27 Glen Road
Sandy Hook, CT 06482
(203) 426-8100
Reproductions of most of the works of art used in this book can be purchased from this company.

Web Sites
Guggenheim Museum
http://www.guggenheim.org/srgm.html
J. Paul Getty Center
http://www.getty.edu/museum/
Louvre
http://www.mistral.culture.fr/louve/
Metropolitan Museum of Art—New York
http://www.metmuseum/org/
Museum of Modern Art—New York
http://www.moma.org/menu.html
Smithsonian Institute
http://www.si.edu/orginaza/offices/archart/start.htm

Technology
The Louve Museum for Kids
CD-ROM (Windows and Macintosh)
The Voyager Company and Gallimard Jeunesse, 1996
576 Broadway, Suite 406
New York, NY 10012
800-446-2001

Barry's Scrapbook
American Library Association
Video
Available from Teachers Video Company
P.O. Box ELG-4455, Scottsdale, AZ 85261
800-262-8837

With Open Eyes
Voyager
CD-ROM (Windows and Macintosh)
Available from Bound to Stay Round Books, Inc.
1880 West Morton, Jacksonville, IL 62650
800-637-6586

Table of Contents *(cont.)*

Table of Contents

W9-BIW-257

MASTERPIECE OF THE MONTH

An Art Appreciation Program for Grades K–5

Written by Jennifer Thomas

Illustrated by Blanca Apodaca and Theresa Wright

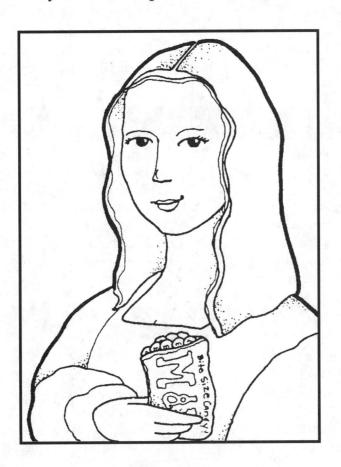

Teacher Created Materials, Inc.
6421 Industry Way
Westminster, CA 92683
www.teachercreated.com

©1990 Teacher Created Materials, Inc.

Reprinted, 2000

Made in U.S.A.

ISBN-1-55734-018-8